"Conrad Mbewe displays the rare ability to combine simplicity and profundity. Here he turns this gift to a consideration of evangelical unity, to gospel unity—both its indicatives (the unity that has been secured by Christ and worked out in us by the Spirit) and its imperatives (how this great reality must drive us toward intentional living out of such unity). We are soon enabled to see that the duty of unity is not an optional extra for believers but simply the outworking of the gospel in our lives."

D. A. Carson, Theologian-at-Large, The Gospel Coalition

"All too often, gospel work may be disrupted *either* by unnecessary division among believers *or* by failure to separate from those who compromise on biblical truth. Conrad Mbewe takes us back to Scripture to find the wisdom we need to tread the tightrope between overscrupulous schism and oversentimental accommodation. This helpful resource is both biblically faithful and very practical. It is grounded in Mbewe's love for the church and his passion to see God glorified as his kingdom is extended."

Sharon James, Social Policy Analyst, The Christian Institute

T0335191

Unity

Union

Growing Gospel Integrity

Michael Reeves, series editor

Worthy: Living in Light of the Gospel, Sinclair B. Ferguson

Unity: Striving Side by Side for the Gospel, Conrad Mbewe

Courage: How the Gospel Creates Christian Fortitude, Joe Rigney

Humility: The Joy of Self-Forgetfulness, Gavin Ortlund

Unity

Striving Side by Side for the Gospel

Conrad Mbewe

CROSSWAY®

WHEATON, ILLINOIS

Unity: Striving Side by Side for the Gospel

© 2024 by Conrad Mbewe

Published by Crossway
> 1300 Crescent Street
> Wheaton, Illinois 60187

Cover design: Jordan Singer

First printing 2024

Printed in the United States of America

Trade paperback ISBN: 978-1-4335-8487-9
ePub ISBN: 978-1-4335-8490-9
PDF ISBN: 978-1-4335-8488-6

Library of Congress Cataloging-in-Publication Data

Names: Mbewe, Conrad, author.

Title: Unity : striving side by side for the gospel / Conrad Mbewe.

Description: Wheaton, Illinois : Crossway, [2024] | Series: Growing gospel integrity | Includes bibliographical references and index.

Identifiers: LCCN 2023038806 (print) | LCCN 2023038807 (ebook) | ISBN 9781433584879 (trade paperback) | ISBN 9781433584886 (pdf) | ISBN 9781433584909 (epub)

Subjects: LCSH: Church—Unity. | Jesus Christ—Mystical body. | Bible. Philippians I, 27—Criticism, interpretation, etc.

Classification: LCC BV601.5 .M39 2024 (print) | LCC BV601.5 (ebook) | DDC 262/.72—dc23/eng20231214

LC record available at https://lccn.loc.gov/2023038806

LC ebook record available at https://lccn.loc.gov/2023038807

Crossway is a publishing ministry of Good News Publishers.

To Charles and Mavis Bota

*By your example you have taught me
true evangelical catholicity. Thank you for striving
side by side with me for the gospel for forty years.*

Contents

Series Preface

GOSPEL INTEGRITY IS, I suggest, the greatest and most vital need of the church today. More than moral behavior and orthodox beliefs, this integrity that we need is a complete alignment of our heads, our hearts, and our lives with the truths of the gospel.

In his letter to the Philippians, the apostle Paul issues a call to his readers to live as people of the gospel. Spelling out what this means, Paul sets out four marks of gospel integrity.

First, he entreats, "let your manner of life be worthy of the gospel of Christ" (1:27a). The people of the gospel should live lives *worthy* of the gospel.

Second, this means "standing firm in one spirit, with one mind striving side by side for the faith of the gospel" (1:27b). In other words, integrity to the gospel requires a *united* stand of faithfulness together.

Third, knowing that such a stand will mean suffering and conflict (1:29–30), Paul calls the Philippians not to be "frightened in anything" (1:28a). He describes this *courage* as "a clear sign" of our salvation (1:28b).

Fourth, Paul writes:

> So if there is any encouragement in Christ, any comfort from love, any participation in the Spirit, any affection and sympathy, complete my joy by being of the same mind, having the same love, being in full accord and of one mind. Do nothing from selfish ambition or conceit, but in humility count others more significant than yourselves. (2:1–3)

Paul thus makes it clear that there is no true Christian integrity without *humility*.

The simple aim of this series is to reissue Paul's gospel-based call to an integrity that means living *worthily*, *unitedly*, *courageously*, and *humbly*. We need to recognize, however, that these four marks are not abstract moral qualities or virtues. What Paul has in mind are, quite specifically, marks and manifestations *of integrity to the gospel*. As such, the books in this series will unpack how the gospel fuels and shapes those qualities in us.

Through this little series, may God be glorified, and may "the grace of the Lord Jesus Christ be with your spirit" (4:23).

Michael Reeves
Series Editor

Introduction

Avoiding Extreme Views of Christian Unity

AS HUMAN BEINGS created by a triune God, we are social creatures. We are meant to relate to other humans in a spirit of unity and mutual benevolence. We thrive best when we are in company with others and working together for the common good. Peaceful coexistence is of the very essence of our humanity, hence the well-known phrase "No man is an island." We want to dwell in a peaceful environment. The subject of peace and unity is vital for us as human beings.

With the entrance of sin into the world, however, one of the areas of human existence most affected has been our ability to coexist in the very atmosphere that we all should long for. Sin has made us so selfish that it jeopardizes our efforts to live together in harmony. As we shall learn in this book,

the coming of Christ not only reconciles us to God but also reconciles us to one another. The church, therefore, should be the place where this deep desire among human beings is realized. While unity is realized to a large extent among genuine Christians, there is a lot we need to do to realize this more fully in actual experience, as we shall see.

R. B. Kuiper wrote in his classic *The Glorious Body of Christ*:

> The plight of the Christian church seems almost as sad as that of the world. To all appearances it, too, is a house divided against itself. It resembles a beautiful vase that, fallen from its perch, lies shattered in a thousand pieces. It is like a grand structure transformed by an exploding bomb into a tangled heap of wreckage. Unbelievable though it may seem, the church of Jesus Christ is really one.[1]

It is this unity that we need to pursue.

When Paul wrote his letter to the Philippians, he was full of joy because of what this church meant to him. It was the church that sponsored his missionary work as he made

1 R. B. Kuiper, *The Glorious Body of Christ: A Scriptural Appreciation of the One Holy Church* (Edinburgh: Banner of Truth, 1967), 41.

his way into Europe. Even when he was imprisoned, this church sent him some much-needed supplies. At the time of his writing the letter, they even sent him one of their most able men, Epaphroditus, so that he could minister to Paul while he was in prison (2:25). Yet he knew that the church would be hindered in its work if it became disunited. So he wanted them to not take unity for granted. Already two ladies in the church whose partnership in the gospel he treasured appeared to have been quarreling, and this reached the ears of Paul while he was in prison. So he appealed to them:

> I entreat Euodia and I entreat Syntyche to agree in the Lord. Yes, I ask you also, true companion, help these women, who have labored side by side with me in the gospel together with Clement and the rest of my fellow workers, whose names are in the book of life. (4:2–3)

Central to the book you are reading is Philippians 1:27. It is an appeal for the church in Philippi to ensure that it would remain united both in fellowship and in ministry. Paul made this appeal based on the gospel. He wanted the Christians in Philippi to live lives worthy of the gospel they had come to know. He wrote,

Only let your manner of life be worthy of the gospel of Christ, so that whether I come and see you or am absent, I may hear of you that you are standing firm in one spirit, with one mind striving side by side for the faith of the gospel.

It was as the Philippians remained gospel-centered that they would stand firm in one spirit and strive side by side for the same gospel. This would happen whether the apostle Paul was among them or not.

This gospel-centered unity—or evangelical unity—needs to be emphasized among Christians no less today. You don't have to be in the church very long before you notice two wrong and opposite—even dangerous—outlooks on Christian unity.

Unity as Merely Organizational?

There are those whose chief concern is merely organizational. They want all who claim to be Christians and Christian churches to come together into some form of global Christian church. Appeal is often made to the words of Jesus in his high priestly prayer, where he said to God the Father, "I do not ask for these only, but also for those who will believe in me through [my disciples'] word, that they may all be one . . . so that the world may believe that you have sent me" (John

17:20–21). The argument is often made that this visible global unity will have an evangelistic allure, as was stated in the prayer of the Lord Jesus Christ. Now, surely, who would not want that?

What those who make this appeal often forget is that this unity is meant for those "who will believe in me through [my disciples'] word." It is a unity of those who have truly believed in the gospel. Whereas belief is in the heart and we should be inclined to accept those who claim to believe, their belief must be based on the gospel as it is revealed in Scripture. This gospel is based squarely on the finished work of Christ by the grace of God without human works added to it. So, for instance, we cannot be in unity with those who believe that the Virgin Mary is a co-redeemer with the Lord Jesus Christ or that we should be praying to her to appeal to her son to have mercy on us. That is a false gospel; it does not save. The unity that our Lord desires is based on what the apostles would proclaim, and we have it in the Scriptures.

There is another dividing line that those who cite John 17 often overlook. It is the fact that although faith is in the heart and therefore cannot be seen, it produces fruit that must be seen. When individuals are converted, they experience a spiritual transformation that is evident to those around them. Jesus saves from sin. If that has not happened, then people

who make a claim to Christianity make a false claim, however sincere they may be. It was the apostle Paul who said to Titus, his protégé, "For the grace of God has appeared, bringing salvation for all people, training us to renounce ungodliness and worldly passions, and to live self-controlled, upright, and godly lives in the present age" (Titus 2:11–12). The grace of God in salvation produces the fruit of holiness. We have no right to include in Christian fellowship individuals and churches that have long abandoned godliness. In fact, if we take the apostle Paul seriously, individuals who show a stubborn affinity for sin must be expelled from the church (see 1 Cor. 6:9–13).

Lastly, advocates for a unity that is merely organizational also forget a crucial phrase in the prayer of the Lord Jesus Christ in John 17. Let me quote verses 20–21 in full. Jesus prayed: "I do not ask for these only, but also for those who will believe in me through their word, that they may all be one, *just as you, Father, are in me, and I in you*, that they also may be in us, so that the world may believe that you have sent me." The prayer of our Lord was not primarily for organizational unity but for spiritual unity. That is what is meant by "just as you, Father, are in me, and I in you." The very real spiritual bond between the persons of the godhead sets the precedent for unity among true believers. As we shall

see, this unity has been achieved by the Lord Jesus Christ and applied to believers by the Holy Spirit. The bond between true believers in Christ is organic rather than organizational. Our task is to maintain it.

We must be careful not to go to the extreme of assuming a unity with everyone who claims to be a Christian. We must ensure that the gospel people claim to believe in is the biblical gospel and that they are bearing its fruit. Commenting on John 17:21, John Calvin wrote,

> Wherefore, whenever Christ speaks about unity, let us remember how basely and shockingly, when separated from him, the world is scattered; and, next, let us learn that the commencement of a blessed life is, that we be all governed, and that we all live, by the Spirit of Christ alone.[2]

Unity as Total Agreement?

The opposite extreme view of Christian unity is found among those who will work together only with those with whom they agree on everything—doctrinal and practical. They often divide over styles of worship, political and social issues, modes

2 John Calvin, *Commentary on the Gospel according to John*, vol. 2, in *Calvin's Commentaries*, vol. 18, trans. William Pringle (Grand Rapids, MI: Baker, 2003), 183.

of child discipline and education, church organization and administration, the use of social media, eschatological views, and so on. As you will notice, these are all non-gospel issues. Granted, our level of interchurch cooperation does depend on how united we are over matters of doctrine and practice, but there should still be some level of cooperation where it is evident that we stand for the same gospel. Refusing all cooperation with fellow believers is surely wrong. If such division were allowed, the New Testament church would have long split between Jews and Gentiles, because in those early days that was what largely threatened church unity.

The apostle Paul addressed this matter in some of his letters, especially Romans and 1 Corinthians. For instance, to the Romans he wrote:

> As for the one who is weak in faith, welcome him, but not to quarrel over opinions. One person believes he may eat anything, while the weak person eats only vegetables. . . .
>
> One person esteems one day as better than another, while another esteems all days alike. Each one should be fully convinced in his own mind. . . .
>
> Why do you pass judgment on your brother? Or you, why do you despise your brother? . . . So then each of us will give an account of himself to God. (14:1–2, 5, 10, 12)

The appeal of the apostle was that the Christians in the church in Rome should remain united even if there was a difference in doctrine and practice over these matters. Not all differences are worth dividing over. On some matters, you can agree to disagree.

I recall many years ago listening to a young pastor who had been called in the middle of the night to help resolve a domestic dispute that was threatening a marriage. "When I got there and was told what the issue was that had reduced the home into a war zone, I could not believe it," he said. "It was so petty." The older pastors quickly told the young pastor that petty issues often fragment families. Christian couples fail to live in harmony because of minor differences. They fail to differentiate between essentials and nonessentials. Sadly, this is not limited to homes. Too many splits between churches are due to the same failure.

As I hope to show in this book, we should be wary of divisions over non-gospel issues. This was the apostle Paul's message to the Philippians, as we have already seen in Philippians 1:27. Whereas his primary concern at that time was for unity within the local church, the same issues that can divide a local church can cause divisions between otherwise godly men and women beyond the confines of the church. Conversely, the same principles that cure divisions in the local church can

also cure divisions between believers outside the church. So, in this book, I will deal with the issue of evangelical unity in the wider body of Christ. As Mark Dever rightly says:

> The church is one and is to be one because God is one. Christians have always been characterized by their unity (Acts 4:32). The unity of Christians in the church is to be a property of the church, and a sign for the world reflecting the unity of God himself. Thus, divisions and quarrels are a peculiarly serious scandal.[3]

What I propose to do is to bring the full orbit of the New Testament to bear upon the words of the apostle Paul in Philippians 1:27. He wanted to continue hearing of healthy unity among the believers in Philippi, despite the doctrinal winds blowing among them, some of which he would allude to later in his letter. The Philippians would need to stand firm in one spirit and one mind if they were going to strive together side by side for the faith of the gospel. Paul wanted this to be exhibited in their manner of life. That remains a huge calling for us in the twenty-first century as many of us lead the church of Christ. It is so easy to go to one of the two

3 Mark Dever, *The Church: The Gospel Made Visible* (Nashville: B&H, 2012), 16.

extremes I have described here, both of which fail to exhibit true evangelical[4] unity. While we resist those two extremes, we need to be clear about what the genuine article looks like. What is *biblical* unity?

R. B. Kuiper warns against the two extremes when he says:

Extreme denominationalism [by which he means the tendency to view your church as the only one right and therefore separate it from other churches] accelerates division and thus obscures the church's unity more than ever but cannot destroy it. Extreme unionism [by which he means the tendency to view all institutions that claim to be Christian as truly Christian and to be brought into some form of organizational unity] spells the destruction of the church but will never be permitted actually to destroy either the church or its purity.[5]

Any Christian leader will face this challenge sooner rather than later. He will soon sense that he is being pulled to one extreme or the other. This is why it is important to be inoculated

4 The term *evangelical* is used in various ways today. I use it, together with the other authors of this book series, to refer to those who believe in salvation by faith alone, through grace alone, and in Christ alone.

5 Kuiper, *The Glorious Body of Christ*, 49.

early in one's ministry from both errors by being convinced concerning the true biblical balance when it comes to unity in the body of Christ. Again, it is not enough for leaders to safeguard themselves and their churches from error; they will also need to purposefully engage in intrachurch and interchurch activities that manifest this unity. What are those activities that glorify God as his people strive side by side for the faith of the gospel? I hope to touch on several of them in this book.

The Indicatives of Christian Unity

1

Unity Is Accomplished in Christ

WHEN WE CONSIDER the subject of Christian unity, it is vital to start with the simple fact that unity is something already secured for us by God. Strictly speaking, our role is not to *become* united but to *remain* united, not to *attain* but to *maintain* unity. Jesus spoke of this unity when he said:

I am the good shepherd. I know my own and my own know me, just as the Father knows me and I know the Father; and I lay down my life for the sheep. And I have other sheep that are not of this fold. I must bring them also, and they will listen to my voice. So there will be one flock, one shepherd. (John 10:14–16)

As far as Jesus is concerned, he has only one flock. In these first two chapters, I want to show how God has achieved this through his Son and his Spirit. He has done what was made otherwise impossible by the fall.

Christ Died to Secure Our Unity

When Jesus Christ died on the cross, he was not only reconciling us to God; he was also reconciling us to one another. This is well illustrated by Paul's explanation to the Ephesians about the unity of Jews and Gentiles in the church. And it can be applied to all the divisions we have among ourselves as human beings—gender, racial, national, financial, tribal, philosophical, and so on. Paul wrote:

> But now in Christ Jesus you who once were far off have been brought near by the blood of Christ. For he himself is our peace, who has made us both one and has broken down in his flesh the dividing wall of hostility by abolishing the law of commandments expressed in ordinances, that he might create in himself one new man in place of the two, so making peace, and might reconcile us both to God in one body through the cross, thereby killing the hostility. (2:13–16)

That phrase "but now" in verse 13 answers the hopeless divide that stood between the Jews and the Gentiles, due not only to their fallenness but also to their religious groupings. Gentiles were outsiders. They were thought of as Gentile dogs (as some Jews would refer to them), because they were "alienated from the commonwealth of Israel and strangers to the covenants of promise, having no hope and without God in the world" (2:12). But all that has now changed in union with Christ Jesus and through his death on the cross. Previously, Gentiles who converted to Judaism were allowed to occupy the outer court of the temple, but now, Paul declared, they "are no longer strangers and aliens" but "fellow citizens with the saints and members of the household of God" (2:19). The division that was once there is no more.

Commenting on this passage, John Stott writes:

This, then, was the achievement of Christ's cross. First, he abolished the law (its ceremonial regulations and moral condemnation) as a divisive instrument separating men from God and Jews from Gentiles. Secondly, he created a single new humanity out of its two former deep divisions, making peace between them. Thirdly, he reconciled this new united humanity to God, having killed through the cross all the hostility between us. Christ crucified has thus

brought unto being nothing less than a new, united human race, united in itself and united to its creator.[1]

The apostle Paul refers to Jesus Christ as our peace because he has secured the peace that was once absent. Life on earth, due to the fall, is characterized by hostility, antagonism, aggression, hatred, and enmity. Genuine love, trust, and peace are rare ingredients in society. Various prophecies about the coming of the Messiah emphasized that he would bring peace among us human beings. For instance, Isaiah wrote,

For to us a child is born,
 to us a son is given;
and the government shall be upon his shoulder,
 and his name shall be called
Wonderful Counselor, Mighty God,
 Everlasting Father, Prince of Peace. (9:6)

As I have already stated, we are promised not only peace with God but also peace with one another. This is evident from the previous verses where Isaiah speaks about the breaking of the

1 John R. W. Stott, *God's New Society: The Message of Ephesians* (Leicester: Inter-Varsity Press 1979), 102.

rod of the oppressor and the burning of the boot of the trampling warrior and his garment that was rolled in blood (9:4–5). This speaks of the end of hostility between human beings.

At the time of the birth of John the Baptist, his father, Zechariah, prophesied about all that the Messiah had come to do

> because of the tender mercy of our God,
> whereby the sunrise shall visit us from on high
> to give light to those who sit in darkness and in the
> shadow of death,
> to guide our feet into the way of peace.
> (Luke 1:78–79)

He was speaking of the coming Messiah as one who would guide his people into the way of peace. And when Jesus was born, the angels sang,

> Glory to God in the highest,
> and on earth peace among those with whom he is
> pleased! (Luke 2:14)

You cannot miss this same message. The Messiah was bringing peace on earth.

Notice that the statement of the apostle Paul to the Ephesians is not an imperative but an indicative. It describes something done. Jesus "has made us both one and has broken down in his flesh the dividing wall of hostility" (2:14). It is not even a statement of hope for the future. It is a statement of fact about what has already been achieved in the past. The church is united despite the divisions that exist between various groupings in the world. In Christ's death, he has removed that which divided us.

In the case of the Jews and Gentiles, it was the "dividing wall" of "the law of commandments expressed in ordinances" (2:14–15). The Pentateuch spells out what the laws and their ordinances were. They consisted of many ceremonial and civil laws. Among the ceremonial laws were offerings for sin, guilt, and peace, as well as grain offerings. Some of them were food, burnt, wave, and ordination offerings. The Israelites also had laws about the cleansing of lepers, the Day of Atonement, sabbaths, a year of jubilee, and so forth. They also had laws regulating their communal life and an entire penal code for various crimes. Any Gentile seeking to become a part of this life had many hurdles to clear.

Jesus fulfilled all of these laws in his life and by his death. Paul was able to say to the Colossians, "Therefore let no one pass judgment on you in questions of food and drink, or with

regard to a festival or a new moon or a Sabbath. These are a shadow of the things to come, but the substance belongs to Christ" (Col. 2:16–17).

One reason Jesus fulfilled the law in this way was to create one new man out of the two and thus achieve peace between them. The point was not that the Gentiles were joining the Jews in their religion or the Jews were joining the Gentiles in theirs. Jesus created a new body called "the church," and everyone comes in on the same terms—repentance toward God and faith in the Lord Jesus Christ (Acts 20:20–21). It is not Jesus plus something peculiar to your group but Jesus alone. *Solus Christus!* We all must say in the words of Augustus Toplady,

Nothing in my hands I bring,
Simply to thy cross I cling.[2]

We must not miss the fact that the reconciliation of which the apostle Paul speaks here starts with our being reconciled to God. Granted, we are most conscious of our hostility toward one another. Yet there is a greater hostility than that. It is God's hostility toward us because we have sinned against him. The

2 "Rock of Ages" (1776), https://hymnary.org/.

Bible says, "The wrath of God is revealed from heaven against all ungodliness and unrighteousness of men, who by their unrighteousness suppress the truth" (Rom. 1:18). Our greatest need is not peace between human beings. It is peace between us and God. We need vertical reconciliation much more than horizontal reconciliation. This is what Jesus achieved on the cross. Out of that reconciliation has flowed our interpersonal reconciliation. That was his twofold mission.

On the cross, Jesus took our place and paid the full penalty for our sin. He suffered the wrath of God in our place and discharged our liability. Our sins were transferred to his account, and he paid for them. His righteousness was transferred to the account of all who trust in him. Through his body on the tree, this transaction was fully accomplished. Since we all come to God in this way—Jew or Gentile, slave or free, educated or uneducated—we are one in him. We lose sight of our superficial differences, thus quenching our hostility. Peter Jeffery makes this point so vivid when he says:

> Jesus did not die so that there would be Jewish Christians and Gentile Christians, but that they should simply be Christians. The national tag is now totally irrelevant. In the same way whether we are young Christians or old Christians is also irrelevant. The age barrier disappears in

Christ as does the national one. If a man is a Christian he is my brother, and not just in theory but in reality.[3]

The apostle Paul finally asserted: "And he came and preached peace to you who were far off and peace to those who were near. For through him we both have access in one Spirit to the Father" (Eph. 2:17–18). Paul's point was that the unity in view was by Christ's initiative, not only through his accomplishing it on the cross but also in his invitation to us all to participate in it. Bryan Chapell comments on these words of the apostle:

> Somehow, deep within all believers there is the understanding that peace between the races and with God comes when, through the sacrifice of Christ, we see ourselves as a child in the lap of our heavenly Father and also see other children—red and yellow, black and white, precious in his sight—held with us in his arms.[4]

Jesus went to both those who were far off (the Gentiles) and those who were near (the Jews), inviting us to come in and

3 Peter Jeffery, *Opening Up Ephesians* (Darlington, UK: Evangelical Press, 2002), 29.

4 Bryan Chapell, *Ephesians*, Reformed Expository Commentary (Phillipsburg, NJ: P&R, 2009), 119.

enjoy peace with God and peace with one another. Through him now we both have access to the God the Father in the same way. This is enabled by the work of the Holy Spirit, as we shall see in the next chapter.

Jesus Prayed for Our Unity

As if this work of reconciliation on the cross were not enough, Jesus also prayed and continues to pray for the unity of the church. In what we call his high priestly prayer in John 17, Jesus said to the Father:

> I do not ask for these only, but also for those who will believe in me through their word, that they may all be one, just as you, Father, are in me, and I in you, that they also may be in us, so that the world may believe that you have sent me. The glory that you have given me I have given to them, that they may be one even as we are one, I in them and you in me, that they may become perfectly one, so that the world may know that you sent me and loved them even as you loved me. (vv. 20–23)

Interestingly, the high priestly prayer of the Lord Jesus Christ assumes his death and finished earthly work. It is as if he was about to ascend to heaven when he offered this

prayer, though chronologically he uttered it before he died. Considering his current mission and the future of his followers, he prayed for himself (vv. 1–5), the apostles (vv. 6–19), and then the rest of us in the church militant—that is, the church engaged in spiritual warfare this side of Christ's second coming (vv. 20–26). It may surprise us that the first issue he prayed for concerning the church militant was its unity. He had already mentioned it when praying for the apostles: "And I am no longer in the world, but they are in the world, and I am coming to you. Holy Father, keep them in your name, which you have given me, that they may be one, even as we are one" (v. 11). I find it amazing that the unity of the church would be such a high priority to Jesus!

Since the Bible says that Jesus ever lives to intercede for believers (Heb. 7:25), we can assume that Christian unity continues to be his prayer for the church on earth. He will continue to pray in this way until he returns to wrap up history at his second coming. What is also comforting about this truth is that, whereas our prayers are not always effectual, because of our sins, the prayers of Jesus Christ have total efficacy. They are based on his finished work on the cross. The Father gladly listens to him and gives him what he requests.

Jesus was primarily praying not for an organizational unity but for an organic one—though, of course, organic unity

would be visible in the way we partner together as Christians and as churches in real terms. This unity also manifests itself in the way members of the human family have an affinity toward one another in genuine love. Brotherly love should pervade the atmosphere in the church. The very DNA of the church should be opposed to disunity and hostility. As Paul put it to the Corinthians, "God has so composed the body, giving greater honor to the part that lacked it, that there may be no division in the body, but that the members may have the same care for one another" (1 Cor. 12:24–25). This is what Christ was praying for, and it is what he has achieved through his death and his intercessory work in heaven.

This organic unity is fashioned after the unity in the God-head between the Father and the Son, as Jesus mentions in his high priestly prayer. There is such an integration of persons in the Godhead that all three are one being, and yet they are still distinct. The Father is not the Son or the Spirit, and yet he is one with them. Likewise, the Son is not the Father or the Spirit, and the Spirit is not the Father or the Son, but each person of the Trinity is one with the other two. The three are distinct persons yet essentially one. They are three in one and one in three. From this organic unity flows their organizational unity. The three persons of the Godhead work together seamlessly in creation, providence, and redemption. In redemption,

the Father chose the elect, the Son redeemed them through his death, and the Holy Spirit regenerates them and brings them into the kingdom. There is a perfect working together.

The prayer of the Lord Jesus Christ in John 17 has no doubt been answered partially in history and will be fully answered when we are all glorified. The partial answer is what I will address in the next chapter as we see how the Holy Spirit works in human hearts to realize what Jesus worked for in his life and death on earth. R. C. Sproul explains in his commentary on John 17:

> There's a very real sense in which this petition already has been fulfilled. Every person who is a Christian is in Christ, so if you are in Christ and I am in Christ, there is a real unity between us by virtue of our common union with him. This is true for all genuine believers. Even though we may differ on this point or that point, there is a real unity that binds us together—and that unity should be evident to the world.[5]

Jesus envisioned that the unity he prayed for would have an evangelistic effect. This is because of the gospel's effects in

5 R. C. Sproul, *John: An Expositional Commentary* (Sanford, FL: Ligonier Ministries, 2009), 305–6.

a world of sin, where human selfishness destroys relationships for personal gain. The world is full of marital fights, family feuds, intertribal and racial wars, civil strife, and international battles. Wherever you find human beings, there will be strife. But Jesus is saying that when the gospel reaches societies and the church is born, onlookers will be amazed at how people from diverse backgrounds have genuine love for one another. They will notice that these people come from different tribes, ethnic groups, and nations, and yet they are united. They will notice that they gladly worship and work together for a common cause. They will have to admit that something extraordinary is happening. They will be forced to give the claims of Christ their attention. How else can they explain the unity among God's people? Where does this love come from?

Jesus Gives Us Incentives for Unity

As human beings we function best when we are persuaded by logic and evidence. We will make sacrifices if we are convinced by logic that the benefits of an action are worth the sacrifice. With respect to Christian unity, several incentives flowing from the work of Christ in our salvation should cause us to pursue visible unity. They should make us eager to express this unity in practice. The apostle Paul referred to this when he wrote to the Ephesians:

> I therefore, a prisoner for the Lord, urge you to walk in a manner worthy of the calling to which you have been called . . . eager to maintain the unity of the Spirit in the bond of peace. There is one body and one Spirit—just as you were called to the one hope that belongs to your call—one Lord, one faith, one baptism, one God and Father of all, who is over all and through all and in all. (4:1–6)

Though I will discuss this in the next chapter as something produced by the Holy Spirit, seeing that this is all secured by virtue of Christ provides motivation to actively realize it in our daily experience. Paul set forth seven theological underpinnings on which we consciously build our unity in Christ. Let us briefly look at each one.

1. It is because of the work of Christ that there is "one body." This was Paul's favorite way of referring to the church, the body of Christ. All who ever become saved are brought into union with Christ and with other believers in this one body. Some may already be in heaven, but we still belong to this one body. We may live in different parts of the world and may not know each other, but we belong together in this one body.

2. It is also because of the work of Christ that we have "one Spirit." We shall soon see how this one Spirit, who lives and works in all true believers, energizes us and enables all of us

in this one body to experience camaraderie in fellowship and in the Lord's work.

3. Because of Christ, we are now called to "one hope" in the final resurrection and an eternity with him in glory. Earlier in his letter to the Ephesians, Paul called it "the hope to which he has called you, . . . the riches of his glorious inheritance in the saints" (1:18).

4. Jesus himself is our "one Lord," whom we serve in all our gospel endeavors. He is the one who has purchased us with his own blood. We are his. He is now exalted and has given us the Great Commission. He will return to reward us for our holy labors for him.

5. The Lord has called us to "one faith," which refers to the gospel-centered doctrines that regulate all our behavior. As Jesus said to his apostles before he went to heaven, those who are made disciples should be taught "all that I have commanded you" (Matt. 28:20).

6. We are all baptized in the name of the Lord Jesus Christ. This refers to both the baptism we experience when we are joined to Christ and the water baptism by which we publicly identify with him, wherever we may be and whatever our social standing.

7. Finally, Jesus has brought us to worship the "one God and Father of all, who is over all and through all and in all." This is the purpose of our existence. It is why we are saved in

the first place. It is to this God that we come from all tribes, languages, and nations.

When you meditate on these seven truths, secured for us in the person and work of the Lord Jesus Christ, it only makes sense that we should strive side by side for him. As intelligent and rational creatures, we should find our sense of logic compelling us to work together for the glory of our great God and Savior, Jesus Christ.

Conclusion

If we keep our eyes on Christ and his work on the cross for us, there will be less cause for the levels of disunity that have plagued the church across history all the way to our present day. This is what Paul had in mind when he challenged the Corinthians about their disunity over personalities. He wrote, "What I mean is that each one of you says, 'I follow Paul,' or 'I follow Apollos,' or 'I follow Cephas,' or 'I follow Christ.' Is Christ divided? Was Paul crucified for you? Or were you baptized in the name of Paul?" (1 Cor. 1:12–13). He was expecting them to answer in the negative, because only Christ was crucified for them, and they were all baptized in his name. Their divisions on party lines were ridiculous in the light of this. The Corinthians needed to concentrate on Christ, and Christ alone. He is the church's one foundation.

This is why we sing:

The church's one foundation
is Jesus Christ, her Lord;
she is His new creation,
by water and the word.
From heav'n He came and sought her
to be His holy bride;
with His own blood He bought her,
and for her life He died.

Elect from every nation,
yet one o'er all the earth,
her charter of salvation:
one Lord, one faith, one birth.
One holy name she blesses,
partakes one holy food,
and to one hope she presses,
with every grace endued.[6]

6 S. J. Stone, "The Church's One Foundation" (1866), https://hymnary.org/.

2

Unity Is Applied by the Spirit

GOD THE FATHER has ordained our unity not only through the person and work of the Son but also through the person and work of the Holy Spirit. Whereas the Son secures this unity, the Holy Spirit applies it to individual Christians and to local churches as they relate to one another. It is only when we see how God does this through the Son and the Holy Spirit that we gain a strong foundation for our understanding and practice of Christian unity. In the previous chapter, we saw how God has accomplished our unity through the person and work of our Lord Jesus Christ. Let us now look at how he applies the work of Christ to us so that we can authentically manifest this unity to the glory of God the Father.

In writing to the Ephesians, the apostle Paul said, "I therefore, a prisoner for the Lord, urge you to walk in a manner

worthy of the calling to which you have been called, . . . eager to maintain the unity of the Spirit in the bond of peace" (4:1, 3). As we have already noted, Paul was urging the Ephesian believers not to attain unity but to maintain it, because the Holy Spirit has already established it among individual believers and local churches. How has he done this? In this chapter I want us to explore that question. Basically, the Holy Spirit takes what Jesus Christ has done for us and applies it to our hearts. As one minister declared to his fellow ministers in 1804: "Christian unity consists in having one heart—renewed, guided, sanctified by the same Spirit. Uniformity is not necessary."[1]

The Holy Spirit Unites Us to the Body of Christ

The Holy Spirit does many things when he brings us to Christ for salvation. For one, he regenerates us and thus enables us to come to Christ in repentance and faith. For another, he opens our blind spiritual eyes so that we can understand the gospel. But the one petal I wish to concentrate on from the flower of salvation is the way the Holy Spirit unites us to Christ and his body at the point of our conver-

1 D. Wilson, quoted in *The Thought of the Evangelical Leaders: Notes of the Discussions of the Eclectic Society, London, during the Years 1798–1814*, ed. John H. Pratt (1856; repr., Edinburgh: Banner of Truth, 1978), 347.

sion and thus secures our unity. The apostle Paul referred to this when he wrote to the Romans, "For as in one body we have many members, and the members do not all have the same function, so we, though many, are one body in Christ, and individually members one of another" (12:4–5). Notice how he included himself with the Romans because this is a universal body not limited by geographical locations. He said the same to the Corinthians:

> For just as the body is one and has many members, and all the members of the body, though many, are one body, so it is with Christ. For in one Spirit we were all baptized into one body—Jews or Greeks, slaves or free—and all were made to drink of one Spirit. (1 Cor. 12:12–13)

The church in Corinth was divided by many artificial barriers. They had been fighting over who among their leaders was the greatest. They had also been quarreling over Gentile and Jewish scruples and which ones to observe in the church. They were in fighting mode over which spiritual gifts were the greatest and should thus be given greater prominence in the worship services. This was especially disputed between those who had the gift of tongues and those who had the gift of prophecy. So, in this chapter (1 Cor. 12), the apostle

Paul began to show them how absurd this division was by insisting that the gifts were given by the same Holy Spirit for the common good. The gifts are supposed to unite and not divide us! He wrote:

> Now there are varieties of gifts, but the same Spirit. . . . To each is given the manifestation of the Spirit for the common good. For to one is given through the Spirit the utterance of wisdom, and to another the utterance of knowledge according to the same Spirit. . . . All these are empowered by one and the same Spirit, who apportions to each one individually as he wills. (1 Cor. 12:4, 7–8, 11)

How did the Holy Spirit achieve this? It was by baptizing them into the body of Christ so that they are united in Christ. Then he proceeded to give them gifts to enable them minister to one another in that body. I am interested in the first part—their baptism into Christ—and how it relates to their unity.

The apostle explained that just as a human body has hands, feet, eyes, ears, and so on, and yet it remains one body, so it is with the body of Christ. We are very different and have different kinds of gifts, but we are all in this one body. How are we one like the human body? Paul said it is because "in one

Spirit we were all baptized into one body—Jews or Greeks, slaves or free" (1 Cor. 12:13). At the point of our conversion, the Holy Spirit immersed us into Christ so that we are all united to him. He is our head, and we (collectively) are his body. This is a spiritual rather than physical union.

The Holy Spirit Indwells Us

The apostle went on to say that the Holy Spirit not only baptized us into the body of Christ but also indwells us from the time of our conversion. To borrow Paul's words in 1 Corinthians, we "all were made to drink of one Spirit" (12:13). This is not a physical drinking. It is the fact that the Holy Spirit came and took residence in us so that every Christian can rightly be called the "temple of the Holy Spirit" (6:19). In this way, he can use us from inside out to carry out his will. This is something that Jesus promised the disciples as part of the package of the new covenant. He said to them in the upper room before he went to the cross:

I will ask the Father, and he will give you another Helper, to be with you forever, even the Spirit of truth, whom the world cannot receive, because it neither sees him nor knows him. You know him, for he dwells with you and will be in you. (John 14:16–17)

What the Spirit does as he indwells us results in the experience of unity among us as believers. Let us look at some of these results.

The Holy Spirit Opens Our Eyes to Christian Truth

The Holy Spirit opens our eyes to Christian truth so that it becomes a compelling worldview to us. The apostle Paul referred to this when he wrote to the Corinthians why they should be different from the surrounding culture in their attitude toward their leaders and preachers: "Now we have received not the spirit of the world, but the Spirit who is from God, that we might understand the things freely given us by God" (1 Cor. 2:12). The truths taught in the Bible become very real to us, from Genesis to Revelation. We understand them and continue to grow in our understanding of them. This is because the Holy Spirit who inspired the prophets and the apostles to write the various books of the Bible is the same one who now resides in us. We benefit from our pastors and other teachers of the word of God, but they are not intermediaries between us and God's word. We can read it and, to a large extent, understand it for ourselves because of the Holy Spirit, who is in our hearts.

This unity in understanding biblical truth is foundational to Christian unity. Whereas we may not see eye to eye on

every jot and tittle in the Bible, true Christians are united in their understanding of essential biblical truths. This is especially true in our understanding of the gospel, because it is the very basis of our salvation. We all agree that we are born sinners who deserve to go to hell because of our sins. We all agree that there is only one Savior, the Lord Jesus Christ, who is the second person in the Trinity. We all agree that he saves us by his life, his death, and his resurrection from the dead. We all agree that we cannot add anything to the finished work of Christ to gain forgiveness from God—it is all of grace. We come to Christ in repentance and faith, and he clothes us in his righteousness. It is on that basis that God pardons us. It is on that basis alone that he will receive us in glory.

This understanding of the way of salvation is directly and indirectly taught in the Bible from Genesis to Revelation. With spiritual eyes opened by the indwelling Holy Spirit, we are enabled to see this and rejoice in it. We find others who are also indwelt by the same Spirit rejoicing in these truths, and that unites our hearts to theirs.

The Holy Spirit Gives Us Love for Other Believers
The indwelling Spirit also gives us love for other believers, wherever we meet them. In writing to the Galatians, the

apostle Paul spoke of the fruit of the Spirit (Gal. 5:22). The very first of these is love. If the Holy Spirit dwells in you, he will make you a loving person. He will empower you from within to care for others. One major expression of this is love for fellow Christians. The Bible refers to this as brotherly love (*philadelphia*). It is the love enjoyed in the natural family when parents and children care for one another more than they care for those outside the family.

This love enables us to accept one another despite our differences and shortcomings. That was what the apostle Paul had in mind when he wrote, "I therefore, a prisoner for the Lord, urge you to walk in a manner worthy of the calling to which you have been called, with all humility and gentleness, with patience, bearing with one another in love" (Eph. 4:1–2). As Christians, we can often irritate one another by our insensitivities and our mistakes in doctrine and practice. It is the love in our hearts for one another that enables us to bear with these faults and keep us united. No wonder Paul said to the Colossians:

> Put on then, as God's chosen ones, holy and beloved, compassionate hearts, kindness, humility, meekness, and patience, bearing with one another and, if one has a complaint against another, forgiving each other; as the Lord has

forgiven you, so you also must forgive. And above all these put on love, which binds everything together in perfect harmony. (3:12–14)

The Holy Spirit Enables Us to Be More Godly

When the Holy Spirit comes to dwell in our hearts, he begins the process of sanctification. We do not use this word often in our daily conversation, but all it means is that he makes us more holy and godly, like the Lord Jesus Christ. Although the power and dominion of sin is broken at the point of our conversion, the presence of sin is still with us, tempting us from within to do evil. The Holy Spirit enables us to die to this sin so that we live more for God. This is a lifelong process. We never arrive in this life. It is our responsibility to actively put to death the misdeeds of the body, but we are enabled to do so more and more by the indwelling Holy Spirit. We ought to be ever grateful to God that this is the case, because without the help of the Spirit, we would be miserable failures. This is why the apostle Paul told the Philippians, "Therefore, my beloved . . . , work out your own salvation with fear and trembling, for it is God who works in you, both to will and to work for his good pleasure" (2:12–13). Yes, it is because he works within us that we can be guaranteed of progress and victory in holiness.

The sins that war against Christian unity are born from selfishness and pride. James wrote: "What causes quarrels and what causes fights among you? Is it not this, that your passions are at war within you? You desire and do not have, so you murder. You covet and cannot obtain, so you fight and quarrel" (4:1–2). This is why genuine unity is impossible in the unbelieving world. Sin makes us selfish and prideful, and so we fail to put the interests of others first. Part of the process of sanctification is putting to death the fountain of such sins and thus enabling an ambience that fosters true godly unity. Paul had this process in mind when he wrote:

> And do not grieve the Holy Spirit of God, by whom you were sealed for the day of redemption. Let all bitterness and wrath and anger and clamor and slander be put away from you, along with all malice. Be kind to one another, tenderhearted, forgiving one another, as God in Christ forgave you. (Eph. 4:30–32)

This is vital when we are thinking about unity beyond our own local churches. We can engage in many gospel endeavors together as the Holy Spirit helps us to kill the competitive spirit born of selfishness and pride. We need the humility of Abraham, who called his nephew Lot aside and said:

Let there be no strife between you and me, and between your herdsmen and my herdsmen, for we are kinsmen. Is not the whole land before you? Separate yourself from me. If you take the left hand, then I will go to the right, or if you take the right hand, then I will go to the left. (Gen. 13:8–9)

We are brethren. Why should we be competing?

The Holy Spirit Gives Us Gifts That Are Interdependent
The Holy Spirit distributes spiritual gifts that enable us to work together to enrich the body of Christ and to reach out to the world. We saw how, in 1 Corinthians 12, the apostle Paul showed that the spiritual gifts were gifted to the church by one and the same Spirit. He said that this was "for the common good" (v. 7). The wider body of Christ was meant to benefit from the individuals who were thus gifted; it was the very purpose of the bestowal of those gifts. Later in that chapter, the apostle argues for the interdependence of the gifts of the Holy Spirit, using the same analogy of the body:

For the body does not consist of one member but of many. . . . If the ear should say, "Because I am not an eye, I do not belong to the body," that would not make it any less a part

of the body. If the whole body were an eye, where would be the sense of hearing? If the whole body were an ear, where would be the sense of smell? But as it is, God arranged the members in the body, each one of them, as he chose. If all were a single member, where would the body be? As it is, there are many parts, yet one body. (vv. 14, 16–20)

The point the apostle was making was that the Holy Spirit gifts his church in such a way as to make us all interdependent. No Christian has all the gifts necessary to carry out the Great Commission. No single church has all the gifts to do so either. We all need one another. The Spirit ensures that it remains this way by how he distributes his gifts in the local and global church. This was evident even among the apostles. Thus Paul testified,

On the contrary, when they saw that I had been entrusted with the gospel to the uncircumcised, just as Peter had been entrusted with the gospel to the circumcised . . . , and when James and Cephas and John, who seemed to be pillars, perceived the grace that was given to me, they gave the right hand of fellowship to Barnabas and me, that we should go to the Gentiles and they to the circumcised. (Gal. 2:7, 9)

They divided up the work upon seeing that the Holy Spirit had gifted them differently, and so they were able to minister to the global need more efficiently. Even today, we need to recognize this if we are going to reach the world. No one church or one nation will reach the world with the gospel. We must work together.

Curtis C. Thomas warns about pastors and churches who isolate themselves:

> This isolation will surely retard the growth of the Gospel in that particular geographical area. It obscures the unity of the body of Christ. It tells the world that Christians are not one in spirit. Not having fellowship with and learning from other brothers and sisters in Christ stunts spiritual growth of that pastor and congregation.[2]

The Holy Spirit Energizes Us in Gospel Endeavors

The Holy Spirit not only gifts us so that we can play our distinctive roles in the body of Christ, but he also energizes us for us to feel compelled to do so from the heart. This is the combustion chamber that drives the church of God. The

2 Curtis C. Thomas, *Practical Wisdom for Pastors: Words of Encouragement and Counsel for a Lifetime of Ministry* (Wheaton, IL: Crossway, 2001), 174.

Lord Jesus was categorical about the effect of the coming of the Holy Spirit on the day of Pentecost. He said, "You will receive power when the Holy Spirit has come upon you, and you will be my witnesses in Jerusalem and in all Judea and Samaria, and to the end of the earth" (Acts 1:8). His coming was to be an empowering activity. We saw the effect of this on Peter on the day of Pentecost itself—he became a courageous preacher. Likewise, in an extraordinary way, the Holy Spirit sent Philip to the Ethiopian eunuch (Acts 8:29) and Peter to the house of Cornelius (Acts 10:19) to share the gospel. The Spirit also told the church in Antioch to release Barnabas and Saul to continue the work of church planting (Acts 13:2). Although today we do not hear an audible voice giving such direct instructions, we can testify of a Holy Spirit–inspired burden in our hearts that gives us a sense of what God wants us to do in gospel endeavors.

Part of the energy to do evangelism comes from the fact that the Holy Spirit makes us firsthand witnesses of his saving and sanctifying grace. His presence in our hearts enables us to know that we are God's children. As Paul wrote to the Romans:

> You did not receive the spirit of slavery to fall back into fear, but you have received the Spirit of adoption as sons,

by whom we cry, "Abba! Father!" The Spirit himself bears witness with our spirit that we are children of God, and if children, then heirs—heirs of God and fellow heirs with Christ, provided we suffer with him in order that we may also be glorified with him. (8:15–17)

This is a glorious reality. We are not left merely to infer from cold logic that we are children of God. There is a real warmth in our hearts that assures us of this fact.

This witness is especially strong in our times of need, particularly when we undergo suffering. God, in a special way, embraces us close to himself. When dark clouds hang over our heads, we experience a love from God that we normally do not experience otherwise. This bracing love is mediated to us by the Holy Spirit, who resides in our hearts. The apostle Paul made this very point earlier in his epistle to the Romans:

Not only that, but we rejoice in our sufferings, knowing that suffering produces endurance, and endurance produces character, and character produces hope, and hope does not put us to shame, because God's love has been poured into our hearts through the Holy Spirit who has been given to us. (5:3–5)

The power that enables us to rejoice in our suffering while we sense God's love for us makes it impossible for us to keep the good news of God's saving grace to ourselves. We want to share it with a world around us that is in misery under the wrath of almighty God. Since we cannot do this alone, we join hands with other believers so that together we may tell the world that Jesus saves.

Conclusion

We should thank God for the role of the Holy Spirit in our lives. As Jesus said to the disciples in the upper room, the Spirit takes the things of Jesus and makes them real to us (John 16:14–15). That is precisely what he has done to enable the church to experience unity. Jesus secured our unity, and the Holy Spirit is applying it to us in more ways than one. We have seen that he has done so by baptizing us into the one body of Christ and by indwelling all who are God's children. We have also seen that by indwelling us, he has blessed us with common experiences and desires, which cause us to want to be together and serve together for the glory of God's name.

No wonder the famous benediction of the apostle Paul ends with the words "and the fellowship of the Holy Spirit be with you all" (2 Cor. 13:14). This fellowship binds us together as one. To borrow the words of Paul to the Philippians,

So if there is any encouragement in Christ, any comfort from love, any participation in the Spirit, any affection and sympathy, complete my joy by being of the same mind, having the same love, being in full accord and of one mind. (Phil. 2:1–2)

Martyn Lloyd-Jones summarizes these truths succinctly:

The unity amongst Christians is a unity which is quite inevitable because of that which is true of each and every one. I sometimes think that that is the most important principle of all. With all this talk about unity, it seems to me, we are forgetting the most important thing, which is that unity is not something that man has to produce or to arrange: true unity between Christians is inevitable and unavoidable. It is not man's creation; it is, as we have been shown so clearly, the creation of the Holy Spirit himself. And my contention is that there is such a unity at this moment among true Christians. I do not care what labels they have on them, the unity is inevitable; they cannot avoid it, because of that which has become true of every single individual Christian.[3]

3 D. Martyn Lloyd-Jones, *God's Way of Reconciliation: An Exposition of Ephesians 2* (Edinburgh: Banner of Truth, 1972), 354.

The Imperatives of Christian Unity

3

Unity Is to Be Jealously Guarded by Believers

IN PHILIPPIANS 1:27, the apostle Paul speaks of his longing to hear that the believers in Philippi are "standing firm in one spirit." In the previous two chapters, we have seen why this is not a far-fetched desire. Jesus Christ has secured such a unity, and the Holy Spirit has applied it to the hearts of God's people. They are not being asked to *become* united. They *are* united. They are being asked to maintain that unity, which is theirs in Christ. This is how it should be with us as believers both within the local church and beyond. Genuine believers are one body in Christ, separated only by space and time. Where space is not a hindrance because we are in proximity to one another or technology has enabled us

to comfortably span that space, we should be "standing firm in one spirit." Our responsibility is to jealously guard that unity.

Those Not to Be Accepted in Evangelical Unity

In saying so, we must guard against an ecumenism that suggests that we should embrace anyone calling himself a Christian or any group calling themselves a church. That would be wrong. The fact that Christian unity is secured in Christ and applied by the Holy Spirit means that only true Christians, who have responded to the gospel in genuine repentance and faith, should be embraced in this unity. This means that the gospel should be the dividing line for this unity. Where there is a seriously defective understanding of the gospel, we cannot with good conscience forge unity. That would betray the Christian faith altogether. Some churches are "synagogues of Satan" (Rev. 3:9). We must not be seen holding hands with them. They are more of a mission field than mission partners.

Martyn Lloyd-Jones brought his eloquence to bear upon this subject:

We are not merely to speak lovingly, or simply to be nice and friendly; we are to speak the *truth* in love. Truth must

always come first. The result is that it is quite impossible to discuss unity with a man who denies the deity of Christ. Although he may call himself a Christian, I have nothing in common with him. If he does not acknowledge this one Lord, born of the Virgin, who worked his miracles, and died an atoning death, and rose literally from the grave in the body, I cannot discuss the unity of the church with him. There is no basis for the discussion of unity.[1]

We must also be wary of pressure for us to be in harmony and accord with individuals who are living in sin and defying church discipline. Our God is a holy God. Holiness is a nonnegotiable in the Christian faith. A. W. Tozer warned in *The Knowledge of the Holy*:

God is holy, and he has made holiness the moral condition necessary to the health of his universe. Sin's temporary presence in the world only accents this. Whatever is holy is healthy; evil is a moral sickness that must end ultimately in death.[2]

1 D. Martyn Lloyd-Jones, *Christian Unity: An Exposition of Ephesians 4:1–16* (Edinburgh: Banner of Truth,1980), 268, emphasis original.

2 A. W. Tozer, *The Knowledge of the Holy* (1961; repr., Milton Keynes, UK: Authentic Media, 2005), 130.

Surely, we cannot overlook this in the name of Christian unity. To do so is to merit the judgment of God.

The teaching of Scripture with respect to individuals who do not prize holiness is for us to have nothing to do with them. As the apostle Paul wrote to the Corinthians, "I am writing to you not to associate with anyone who bears the name of brother if he is guilty of sexual immorality or greed, or is an idolater, reviler, drunkard, or swindler—not even to eat with such a one" (1 Cor. 5:11). If we associate with such individuals, we blunt our witness to the world and we incur God's temporal judgment upon ourselves. As Jesus said: "You are the salt of the earth, but if salt has lost its taste, how shall its saltiness be restored? It is no longer good for anything except to be thrown out and trampled under people's feet" (Matt. 5:13). Let us not sacrifice the good of the church and the glory of God on the altar of unity for pragmatic reasons. Our unity should be marked by these words: "Holy to the Lord."

Evangelical Unity Despite Secondary Differences

While we need to guard distinctions between the true gospel and false gospels, between holiness and unholiness, we should also shun a brand of "Christianity" that makes class distinctions. We should never accept a "Christianity" that

divides us into separate camps of rich and poor, educated and uneducated. We should fight against the practice of white people worshiping alone and black people worshiping alone simply because of skin color. Even when those divisions persist in our society, they should not prevail in our churches. The gospel should unite us in practice as well as principle. Our fellowship should remove all these social boundaries, because we are one in Christ. The world should see that we are different and that the gospel has broken down all these walls of hostility that find expression in our society. This is the unity that we should seek to realize.

We often forsake this kind of unity because we fail to draw boundaries for Christian fellowship where the gospel draws them. We come up with our own boundaries, which are often "tribal" (for lack of a better word). We have agendas that are not gospel agendas. While it is true that the more united we are in doctrine, the more we will have to do with one another, we build wrong fences if we have nothing to do with other believers unless they stand precisely where we stand doctrinally. That is cultic. No one has a monopoly on the truth. We have a lot in common with other believers by virtue of having a common Savior and being indwelt by the same Spirit. We cannot throw all that away because we do not see eye to eye on less-central aspects of truth. We should

join hands in broad daylight, defining where we stand in contrast to each other and where we stand in harmony. We must make much of that commonality for our mutual good and the glory of God.

I love Curtis C. Thomas's list of what we have in common. He says:

> Conservative, evangelical churches have many basics in common—a commitment to the inspired, inerrant word of God, the divinity of Christ, salvation by grace through faith alone, the reality of heaven and hell, the necessity of spiritual growth and godliness, to mention but a few. There is much rich fellowship to be enjoyed when fellow believers are committed to these principles, even though we may be in different congregations or denominations.[3]

Albert Molher of the Southern Baptist Theological Seminary proposes the idea of "theological triage" to help us weigh doctrinal differences as we think about forging Christian unity. By "triage," he means sorting truths into three levels:

3 Curtis C. Thomas, *Practical Wisdom for Pastors: Words of Encouragement and Counsel for a Lifetime of Ministry* (Wheaton, IL: Crossway, 2001), 174.

First-level theological issues would include those doctrines most central and essential to the Christian faith. Included among these most crucial doctrines would be doctrines such as the Trinity, the full deity and humanity of Jesus Christ, justification by faith, and the authority of Scripture. . . .

The set of second-order doctrines is distinguished from the first-order set by the fact that believing Christians may disagree on the second-order issues, though this disagreement will create significant boundaries between believers. . . .

Second-order issues would include the meaning and mode of baptism. Baptists and Presbyterians, for example, fervently disagree over the most basic understanding of Christian baptism. . . .

Third-order issues are doctrines over which Christians may disagree and remain in close fellowship, even within local congregations. I would put most of the debates over eschatology, for example, in this category.[4]

The main advantage of theological triage is that it helps us to draw the line where it should be drawn in terms of Christian

4 Albert Mohler, "A Call for Theological Triage and Christian Maturity," Albert Mohler (blog), July 12, 2005, https://albertmohler.com/.

fellowship. Truths that are fundamental to Christianity, because people go to hell if they do not believe in them, are nonnegotiables. We must draw our boundaries for fellowship there. Truths that are important enough for Christian life and practice will divide us into different church denominations but also allow many opportunities to work together for the gospel of Christ. That is Mohler's point, and I think he makes a good case.

Bemoaning the tendency of Christians to divide over secondary issues, R. B. Kuiper writes:

Protestant churches have been split by the demand of serious-minded Christians that church members live by eleven or twelve commandments instead of ten. It is at this point that the virtue of piety degenerates into the vice of piosity. At the same point the sin of sectarianism has frequently raised its ugly head. To divide the church on what according to the word of God is an "indifferent" matter—that is to say, a practice which God has neither condemned nor commanded—is the essence of sectarianism. Once more, failure to keep the various teachings of Scripture in balance with each other and the consequent stressing of one or some of them out of all proportion to others, have frequently destroyed the visible unity of

Christ's church. Riding a theological hobby is by no means an innocent pastime. Of such sins it behooves churches everywhere to repent, and from them they must desist.[5]

Other Causes of Evangelical Disunity

Often the refusal of true believers to associate with each other despite having much in common is due to the *strong personality differences of their leaders*. History is full of such examples. James Durham (1622–1658) noticed this in his own day and stated,

> Oftentimes the rise of a division, is in the alienation of affections between some persons . . . , and indeed often the stick is here, that men's affections are not satisfied one with another, and that maketh them that they do not trust each other.[6]

Good men have differed on secondary issues, their strong feelings often fueled by their personal knowledge of each

5 R. B. Kuiper, *The Glorious Body of Christ: A Scriptural Appreciation of the One Holy Church* (Edinburgh: Banner of Truth, 1967), 53–54.

6 Iain H. Murray, ed., *The Reformation of the Church: A Collection of Reformed and Puritan Documents on Church Issues* (1965; repr., Edinburgh: Banner of Truth, 1987), 372.

other. As a result, they have led their Christian followers to line up behind them in fights that, strictly speaking, were not the concerns of those followers. Allegiance to their leaders explains why some nonissues have become do-or-die matters, generating much heat. Once these leaders go to heaven and another generation arises that has no allegiance to them, everyone wonders why such issues were allowed to bring so much disunity among otherwise good men and women.

We need to learn what Paul sought to teach the Corinthians by his soul-searching questions: "What I mean is that each one of you says, 'I follow Paul,' or 'I follow Apollos,' or 'I follow Cephas,' or 'I follow Christ.' Is Christ divided? Was Paul crucified for you? Or were you baptized in the name of Paul?" (1 Cor. 1:12–13). Or as he later put it succinctly: "I planted, Apollos watered, but God gave the growth. So neither he who plants nor he who waters is anything, but only God who gives the growth" (1 Cor. 3:6–7). We need to raise our eyes higher than our human leaders and recognize the God who alone truly matters. Our leaders are mere servants in his hands. They come and go, but it is God—his word and his kingdom—that remains steadfast and secure. We must align ourselves primarily with this God.

Another major cause of division among believers is that we come from *differing cultural traditions* as we enter church life.

We never come with a clean slate. Our past social and religious experiences inform our expectations and color our judgment. The saying is true, "One man's meat is another man's poison." This was what threatened the early church as Jews and Gentiles assembled together. So the apostle Paul wrote:

> As for the one who is weak in faith, welcome him, *but not to quarrel over opinions.* One person believes he may eat anything, while the weak person eats only vegetables. Let not the one who eats despise the one who abstains, and let not the one who abstains pass judgment on the one who eats, for God has welcomed him. (Rom. 14:1–3)

Paul also dealt with differences regarding observance of religious days. These contentious issues were threatening to split the church in Rome.

It is the same today. John MacArthur comments on these verses:

> Outright sin is not the only danger to a church's spiritual health and unity. Although they are not sin in themselves, certain attitudes and behavior can destroy fellowship and fruitfulness and have crippled the work, the witness, and the unity of countless congregations throughout church

history. These problems are caused by differences between Christians over matters that are neither commanded nor forbidden in Scripture. They are matters of personal preference and historic tradition, which, when imposed on others, inevitably cause confusion, strife, ill will, abused consciences, and disharmony."[7]

Our different social backgrounds can result in very strong biases with respect to political views, worship styles, dressing, and so on. We have different scruples and qualms, and end up quarreling with, despising, and condemning one another. We use unloving, strong, and derogatory words against those who do not share our views, and these words injure them and break down fellowship. Yet God has intentionally made his church to be multicultural. John Piper points out one reason for this: "By focusing on all the people groups of the world, God undercuts ethnocentric pride and puts all peoples back upon his free grace rather than any distinctive of their own."[8]

Another cause of disunity between evangelicals is an *unforgiving spirit*. Since we are not yet perfect but are still being

7 John MacArthur, *The MacArthur New Testament Commentary: Romans 9–16* (Chicago: Moody Publishers, 1994), 272.

8 John Piper, *Let the Nations Be Glad: The Supremacy of God in Missions* (Grand Rapids, MI: Baker, 1993), 217.

sanctified by faith in Christ, we will brush each other the wrong way. In Africa we have a proverb that says, "Trees that are close to each other will have their branches rubbing against each other." It is inevitable. We will say and do things against one another that are unwise at best and plain sinful at worst. These will injure the brethren. Some hurts take longer to get over than others. Those wounded often go around with a grudge and end up wanting to kill the fly on a brother's head using a ten-pound hammer. Fellowship is destroyed by individuals who nurse hurt pride from unresolved issues. People refuse to address the matters by talking with those who hurt them, and so they continue to spread bitterness toward their offenders wherever they go.

This is why the appeal of Paul to his "true companion" in Philippians 4:2–3 is so important:

> I entreat Euodia and I entreat Syntyche to agree in the Lord. Yes, I ask you also, true companion, help these women, who have labored side by side with me in the gospel together with Clement and the rest of my fellow workers, whose names are in the book of life.

Paul is emphatic; we need to help nip the flower of personal contention in the bud. Such disagreements often go beyond

two individuals and easily engulf the whole church. Then from that congregation, the differences cause a cleavage between the saints in an ever-widening circle. Elsewhere, it is called a "root of bitterness." The writer of the letter to the Hebrews warns us about this: "See to it that no one fails to obtain the grace of God; that no 'root of bitterness' springs up and causes trouble, and by it many become defiled" (Heb. 12:15). We often underestimate the effect of this and therefore do not give it the attention it deserves.

Too many Christians are fighting battles they have no business with, simply because they have been drawn in by their allegiance to individuals who have scores to settle with their *perceived ecclesiastical adversaries.* The animosity is veiled under the claim that an issue must be addressed or else the Christian faith will suffer a mortal wound. But anyone who compares the amount of dust being raised relative to the importance of the issue at hand soon realizes that there must be some other deep underlying issues. The heat being generated is not in proportion to the issue at hand. Often a personal grudge is driving the entire train into a gorge. It must be stopped.

The wedge that often worsens such disunity is the sin of slander. This is beyond gossip and talebearing. Slander is motivated by the inner desire to pass on false or unverified information about someone else to damage his or her reputation.

It is a fruit of malice. As individuals go into warring camps, they not only fight over the issue in question but also sniff around for or gladly receive damaging information about their perceived opponents. They welcome stories that supposedly show how hypocritical or senseless or morally depraved their adversaries are. As soon as they have this ammunition, they quickly give it wings and let it fly. There is no effort to verify the stories. There is no care about what such news will do to the other person's ministry. In fact, where the informer uses words of doubt ("maybe," "perhaps"), such words are omitted in the retelling, and a rumor is now passed on as truth.

Slander, for all its accusation of others' sin, is itself a sin that must be repented of. It is ugly and must never be on the lips of God's children. The chief slanderer is the devil. Charles Haddon Spurgeon warned us concerning him:

> Satan always hates Christian fellowship; it is his policy to keep Christians apart. Anything which can divide saints from one another he delights in. He attaches far more importance to godly intercourse than we do. Since union is strength, he does his best to promote separation.[9]

9 Charles H. Spurgeon, "Satanic Hindrances," sermon 657 in *The Metropolitan Tabernacle Pulpit Sermons*, vol. 11 (London: Passmore & Alabaster, 1865), Christian Classics Ethereal Library, https://ccel.org/ccel/spurgeon/sermons11/.

We should never be in league with the devil or carry out his agenda. The apostle Paul wrote: "Let all bitterness and wrath and anger and clamor and slander be put away from you, along with all malice. Be kind to one another, tenderhearted, forgiving one another, as God in Christ forgave you" (Eph. 4:31–32).

Slander must be put away. Its root is an unforgiving spirit. It does a lot of damage to the unity we ought to have in the body of Christ. Therefore, the sooner it is repented of, the better for us and for everyone else. As James put it concisely, "Do not speak evil against one another, brothers" (James 4:11). Nothing can be clearer than that.

Activities to Help Us Maintain Evangelical Unity

We must be deliberate about several activities if we are to maintain unity among ourselves as God's people. Here are a few of them.

1. We must grow in our understanding of the gospel and of Christian truth in general. Unity in the faith cannot deepen when it is only based on nice feelings, good music, and vague words. You can get those things anywhere in the world. They are superficial and never sustain rich, lasting unity. Christian unity is based on truth. The more truth we have in common,

the closer our affinity is to one another. That was why it was important to start this book with two chapters on what God has done to secure our unity. It is the doctrinal bedrock on which Christian unity is built. Without that foundation, any form of unity among believers is fickle. It will not survive. If we are going to experience deep, long-lasting unity, we need to encourage Christians to think deeply about doctrinal truths.

That is one reason God has given the church elders who labor in the word and doctrine. It is to enable believers to grow in their knowledge of Christian truth. As they do so, they will minister to one another and to the world with a unity that will withstand the attacks of the evil one. This is what the apostle Paul had in mind when he wrote,

> And he gave the apostles, the prophets, the evangelists, the shepherds and teachers, to equip the saints for the work of ministry, for building up the body of Christ, until we all attain to the unity of the faith and of the knowledge of the Son of God, to mature manhood, to the measure of the stature of the fullness of Christ. (Eph. 4:11–13)

This unity of the faith is a doctrinal unity. It is attained as believers are regularly taught by their shepherds. The fruit of

this is an equipping for ministry so that the body of Christ grows qualitatively and quantitatively.

The phrase "Doctrine divides but love unites" is true only where people are prideful and divisive. In other words, *people* divide by misusing doctrine. Sometimes doctrine divides those who are in serious error from those who are seeking saving truth; it divides between those who espouse heresy and those who have the true gospel. That kind of division, sad though it is, must be recognized because one group makes up the mission field and the other group comprises the missionaries. Why should the two hold hands in the dark? Where there is the fruit of the Spirit, genuine humility enables individuals to be patient with those who sincerely want to learn. Instead of division, there is great fellowship around God's truth in an ever-growing way. Those who are filled with the Spirit are not indifferent to heresies in the church. Rather, they continue to pray for the end of divisions caused by heretical teachers.

2. We must grow in love and concern for other believers. When the apostle Paul noted the fragmentation in the church in Corinth over every conceivable obstacle (the personalities of their leaders, food sacrificed to idols, the Lord's Supper, spiritual gifts, and so on), he gave them a principle that would

overcome these obstacles, and especially the competitive spirit over spiritual gifts. He wrote at some length:

> But earnestly desire the higher gifts.
>
> And I will show you a still more excellent way.
>
> If I speak in the tongues of men and of angels, but have not love, I am a noisy gong or a clanging cymbal. . . .
>
> Love is patient and kind; love does not envy or boast; it is not arrogant or rude. It does not insist on its own way; it is not irritable or resentful; it does not rejoice at wrongdoing, but rejoices with the truth.
>
> Love bears all things, believes all things, hopes all things, endures all things.
>
> Love never ends. . . .
>
> So now faith, hope, and love abide, these three; but the greatest of these is love. (1 Cor. 12:31; 13:1, 4–8, 13)

A key to preventing ecclesiastical divisions is biblical love.

Where individuals have hurt one another, "love covers a multitude of sins" (1 Pet. 4:8). Where there is true Christian love, vices that put brethren on a war path with each other can be dealt with in an atmosphere of God-glorifying grace. We are commanded to love one another. Out of this love, we are also to honor one another, live in harmony with one

another, accept one another, agree with one another, serve one another, bear with one another, be kind to one another, forgive one another, submit to one another, encourage one another, confess our sins to one another, pray for one another, offer hospitality to one another, and so on. These are the attitudes and actions that show the depth of Christian unity. It is deep. If we are to enhance unity among ourselves as believers, we need to be intentional about loving one another.

The perfect example of this is that of the Lord Jesus Christ. Paul wrote to the Philippians:

> So if there is any encouragement in Christ, any comfort from love, any participation in the Spirit, any affection and sympathy, complete my joy by being of the same mind, having the same love, being in full accord and of one mind. Do nothing from selfish ambition or conceit, but in humility count others more significant than yourselves. Let each of you look not only to his own interests, but also to the interests of others. Have this mind among yourselves, which is yours in Christ Jesus. (2:1–5)

Paul went on to describe the humiliated and exalted Christ. He is both our Savior and our example. If we follow in his

steps, we will foster an environment where Christian unity thrives.

3. We must not neglect the opportunities to meet with the people of God. Fellowship dies when Christians take one another for granted and stop making a special effort to be with each other. While technology has bridged the communication gap in an incredible way, it can never replace being with fellow believers in the same space and time. The early church in Jerusalem was described in this way:

> And they devoted themselves to the apostles' teaching and the fellowship, to the breaking of bread and the prayers. . . . And all who believed were together and had all things in common. . . . And day by day, attending the temple together and breaking bread in their homes, they received their food with glad and generous hearts. (Acts 2:42, 44, 46)

In the context of such meetings, you get to know fellow believers and they also get to know you. You see their needs and can do what you can to meet those needs, as was the case in the early church. Your knowledge of one another makes it difficult for other people to drive a wedge between you

through slanderous accusations. It is easier for them to do so if you do not spend time together.

Though our primary source of fellowship should be in the local church, we should go beyond the local church in having face-to-face fellowship with other believers. Pastors should seek out other pastors in their area and seek to make time for fellowship. As Curtis C. Thomas puts it:

> In each geographical area there should be evangelical ministerial associations in which the pastors can get to know each other. From those gatherings can spring the plans to help churches work together and thereby unify the universal body of Christ. The more fractured we are, the greater we become spectacles to the world. The more we are united in love, the more the world sees of Christ.[10]

Christians should look out for local area conferences and camps and carve out time to be there. It is amazing how much you discover you have in common with believers from other churches, even other denominations! This realization deepens Christian unity. We need to heed the appeal of the writer of the letter to the Hebrews, which says, "And let us

10 Thomas, *Practical Wisdom for Pastors*, 175.

consider how to stir up one another to love and good works, not neglecting to meet together, as is the habit of some, but encouraging one another, and all the more as you see the Day drawing near" (Heb. 10:24–25). The "good works" that we encourage in one another will be the subject of the next chapter as we consider striving side by side for the cause of the gospel.

4

Unity Is to Be Evidenced
in Gospel Endeavors

WHEN WE AS CHRISTIANS stand firm in one spirit, it is for
the purpose of making known the gospel of the Lord Jesus
Christ together. Our unity in fellowship makes us close ranks
in spiritual warfare. That was what Paul had in mind in the
text that has inspired this book: "Only let your manner of life
be worthy of the gospel of Christ, so that whether I come and
see you or am absent, I may hear of you that you are standing
firm in one spirit, with one mind striving side by side for the
faith of the gospel" (Phil. 1:27). As the believers in Philippi
stood in one spirit and one mind, they would proceed to
strive side by side for the faith. Ultimately, this must be our
goal. John S. Hammett puts it this way:

Local churches partake of the oneness of the universal church to the degree that they hold to the one Lord and one faith of that one church. . . . Such unity should find expression in how the local church interacts with other local churches who also profess the faith of the gospel and are thus one with them.[1]

Unity for Gathering and Perfecting the Saints

The authors of the Westminster Confession of Faith captured this need for our unity in gospel endeavors in their doctrinal statement on the church. They not only defined what the universal church was but also stated that Christ gave to this universal church the responsibility to propagate the gospel. Chapter 25 says:

2. The visible church, which is also catholic or universal under the gospel (not confined to one nation, as before under the law), consists of all those throughout the world that profess the true religion; and of their children: and is the kingdom of the Lord Jesus Christ, the house and family of God, out of which there is no ordinary possibility of salvation.

1 John S. Hammett, *Biblical Foundations for Baptist Churches* (Grand Rapids, MI: Kregel, 2005), 53.

3. Unto this catholic[2] visible church Christ hath given the ministry, oracles, and ordinances of God, for the gathering and perfecting of the saints, in this life, to the end of the world: and doth, by his own presence and Spirit, according to his promise, make them effectual thereunto.[3]

We may differ on whether children are included in the church, but all true Christians will easily concur with the authors that Christ has given to this "catholic visible church . . . the ministry, oracle, and ordinances of God, for the gathering and perfecting of the saints, in this life, to the end of the world." So, to simply ensure fellowship among ourselves would be insufficient. We must go on to do God's work together for the extension of God's kingdom here on earth until the Lord Jesus Christ returns at the end of history.

Some Necessary Assumptions

Laboring together in gospel endeavors assumes that we have a common understanding of the gospel. This must be a basic minimum and explains why I emphasized this in the

2 The word *catholic* here, as in the previous paragraph, does not refer to the Roman Catholic Church but simply means "universal."

3 *Creeds, Confessions, and Catechisms: A Reader's Edition*, ed. Chad Van Dixhoorn (Wheaton, IL: Crossway, 2022), 225.

previous chapter. Those who believe in salvation by grace alone, through faith alone, and in Christ alone cannot serve together in gospel endeavors with those who think that our good works merit God's favor in salvation. The two messages are diametrical opposites. To those of us in the first category, all who introduce good works as a way of meriting God's favor in salvation are a mission field. We want to help them come to salvation. So, we cannot serve side by side with them. This is why we cannot join hands with everyone and anyone who claims the title "Christian" or "church." We need to know a professing Christian's understanding of the good news of Jesus Christ.

Teamwork in gospel ministry also assumes that churches and Christians are in regular fellowship with one another. I have already asserted that this fellowship is the foundation on which we build togetherness in service and ministry. It is in such fellowship that you form strong bonds with one another and discover others' gifts and talents to enrich your gospel efforts. When you are in communion with one another, you sense the love that others have for your Master and their zeal for his cause. You may not see eye to eye on everything, but you see in them a kindred spirit and want to serve alongside them. You admire them. You want to learn from them as you serve together. You realize they can enrich your life spiritually

and in many other ways. This is what regular fellowship with the saints will do for you.

Among members of the same church, this fellowship requires meeting regularly. Spending time together with Christians in other churches also requires intentional effort. The latter is where we are often lacking, and this robs us of opportunities to enrich one another's lives. We need to find time to attend Christian conferences and seminars beyond our local churches if we are going to know other Christians outside our congregations in any meaningful way. In fact, that is one place where we can strive side by side. We can organize conferences and evangelistic campaigns with Christians in other churches.

I have never forgotten how my own spiritual life was enriched during my university days when I was in regular fellowship with believers from other denominations in our International Fellowship of Evangelical Students (IFES) group on campus. We often argued over doctrines, and sometimes unwisely, but the bonds forged in those days have lasted us almost half a century. We not only met for Bible study and prayer but also organized evangelistic campaigns together. We saw many fellow students coming to repentance and faith in Christ in those days. We knew we had a common gospel and labored together to know Christ and to make him known.

One fruit of this was that long after our student years, we have called on one another to serve in various Christian causes around the country. We would never have done so if we had not formed those deep spiritual bonds in our university days. We only impoverish ourselves when we limit our Christian interaction to those within our churches or denominations.

Charles Haddon Spurgeon bemoaned the lack of unity in the church that resulted in so little being accomplished for Christ. He said in one sermon:

> The Church of Christ is always quarrelling—but did you ever hear that the devil and his confederates quarrel? . . . They are so united that if at any special moment the great . . . prince of Hell wishes to concentrate all the masses of his army at one particular point, it is done to the tick of the clock, and the temptation comes with its fullest force just when he sees it to be the most likely that he will prevail. Ah, if we had such unanimity as that in the Church of God, if we all moved at the guidance of the finger of Christ, if all the Church could . . . move in one great mass to the attack [of] a certain evil, . . . how much more easily might we prevail! But, alas, . . . the powers of Hell far exceed us in unanimity.[4]

4 Charles H. Spurgeon, "An Antidote to Satan's Devices," sermon 2707 in *The Metropolitan Tabernacle Pulpit Sermons*, vol. 46 (London: Passmore & Alabas-

Areas in Which to Labor Together for Christ

There are several areas in which we can strive together for the crown rights of our Lord Jesus Christ. Let me list a few.

1. Book publishing. Very few churches have the financial strength and literary gifts to launch an internal publishing ministry. If we are going to publish good, solid books written by those with clear minds and sound theology in our day, we will need to pull together financial and human resources from beyond the confines of our local churches. This is what has happened across history ever since the Reformation. With the aid of the printing press, Christians have pooled their talents to form publishing companies and get the word, especially the Bible itself, into as many homes as possible. This has demanded assembling a spectrum of experts in Hebrew and Greek, and in the languages into which the Bible was being translated. Also needed have been benefactors who love God's word and want to see it distributed to people who desperately need to read it. This has been accomplished only because Christians have been willing to put aside their lesser differences and strive together for the greater common good.

ter, 1900), Christian Classics Ethereal Library, https://ccel.org/ccel/spurgeon /sermons46/.

2. Theological training. The church rises and falls in sync with the quality of its leaders. It is vital, therefore, to ensure that wherever the church is, there are good training facilities for pastors and other church leaders. Whereas some churches can have the financial muscle and expertise within their ranks to put together such training opportunities, these are few and far between. In most cases, churches must pool their resources for this to happen. Due to the nature of pastoral and theological training, the more united you are in doctrine, the greater the possibility of working together. However, even where you find that you cannot form a common training institution, you can still share lecturers in courses where you see eye to eye, such as the biblical languages. It takes years for individuals to become experts in various fields. Some of them write books that can teach us from afar. Others may live close enough to visit your church. Why not invite them to lecture for the benefit your people and nearby churches? We can all be the richer for it.

3. Medical and educational institutions. Wherever the gospel has gone in the world, the livelihood of the people has been enriched through medical and educational institutions. The Christian faith in that sense has uplifted the living conditions of people who themselves have not necessarily become

Christians. Such institutions convince many skeptics of the love of God as they see Christians serving among them out of compassionate hearts. Even in countries that oppose the Christian faith, governments have allowed such institutions because they know how their citizens benefit from them.

Development of such institutions in mission fields means putting up buildings and employing personnel from various church backgrounds. It also requires a continuous supply of consumables, such as medical supplies. Christians should strive side by side in supporting and working together in such institutions. As with publishing and theological training, very few churches can handle such projects alone. A wider constituency of believers must work together to pull off such projects.

4. Fighting social ills. We live in a fallen world where sin manifests itself in the very structures of society. Those given over to their sinful ways tend to stubbornly push their agendas on others to strengthen their grip on the popular mind. While the church is called to preach the gospel and thus see lives transformed, it is not long before Christians from various church denominations realize that they need to work together in their communities to address social vices. Pornographic materials and gambling houses are licensed, to the

moral degradation of society. Drug traffickers deceive unwary young people until they are hooked. Babies are aborted. Government officials trample basic human rights to remain in power. Eventually, the consciences of Christians get stung, and they come out of the woodwork to speak up against what is patently wrong.

In such times, Christians need to lock arms amid society because they have common values arising from their shared understanding of God's word and the gospel. They can form organizations and work together in campaigns. That is how slavery and the slave trade were outlawed over the centuries. It was largely by the concerted effort of a growing number of Christians working together for many years beyond the confines of their local churches. With governments around the world becoming more intolerant toward Judeo-Christian values, we may see ourselves needing to cooperate even more in the years ahead.

Curtis C. Thomas offers this summary of opportunities:

Local churches can also accomplish much more when they join forces to promote God-honoring activities. Among these are local ministries to the poor, area evangelistic teams, joint Bible conferences, Reformation weekends, pulpit vacation supply, social programs designed to help

neighborhoods, ministries designed to provide alternatives to abortion, joint support of Christians who run for public office, multi-church picnics and other outings, and joint prayer meetings. There are so many things we can do to be a solid, collective witness to our community.[5]

The Need for Integrity and Transparency

To strive together for the common cause of Christ in the world, we need integrity and transparency. Nothing hampers teamwork among Christians more than broken trust because someone has used others' financial support, meant for the institution, to benefit himself. Such an individual has little regard for how much harm he causes by his selfishness. This often happens when there are insufficient accountability structures, and so an organization's funds can be syphoned without detection or consequence.

Accountability requires transparency in the way work is done and the way funds are spent. Whereas it is easier to secure integrity and transparency in local churches because church members who give the funds demand an accounting, it is not that simple when it comes to institutions and

5 Curtis C. Thomas, *Practical Wisdom for Pastors: Words of Encouragement and Counsel for a Lifetime of Ministry* (Wheaton, IL: Crossway, 2001), 175.

organizations beyond the local church. This is why many believers limit their involvement and support to events and causes within their churches. They feel less vulnerable. Thankfully, where the grace of God has done a thorough work, Christians value integrity and have no fear of being transparent. This results in a greater ability for believers who live on different ends of the globe to work together in an ever-growing way.

The Example of the Apostle Paul

I want to end this chapter by seeing what lessons we can learn from the life of the apostle Paul about working with other believers for the great cause of Christ in the world. As he went around planting churches, Paul found himself engaging with believers in many churches. His apostolic teams comprised individuals who were initially in various churches but who became his traveling companions. For instance, Luke's list of names of those on Paul's team as the apostle bid farewell to the elders in Ephesus includes "Sopater the Berean, son of Pyrrhus . . . ; and of the Thessalonians, Aristarchus and Secundus; and Gaius of Derbe, and Timothy; and the Asians, Tychicus and Trophimus" (Acts 20:4). This was truly an interchurch team! These individuals played distinct roles in Paul's ministry, and because of them Paul was able to do much for the growth of Christ's kingdom on earth. When

Paul was going to take donated supplies from the churches in Europe to the churches in Judea, he also worked with an interchurch group. He wrote:

> But thanks be to God, who put into the heart of Titus the same earnest care I have for you. . . . With him we are sending the brother who is famous among all the churches for his preaching of the gospel. . . . And with them we are sending our brother whom we have often tested and found earnest in many matters, but who is now more earnest than ever because of his great confidence in you. As for Titus, he is my partner and fellow worker for your benefit. And as for our brothers, they are messengers of the churches, the glory of Christ. (2 Cor. 8:16, 18, 22–23)

Paul knew how to bring together teams from various churches to do what was best undertaken as interchurch projects. We could learn a lot from his example.

Paul also had some painful experiences as he worked with others for the kingdom of God here on earth. Perhaps the best known was the time he and Barnabas were abandoned by John Mark in Pamphylia soon after they undertook their missionary journey from Antioch. The reason is not given in Acts 13, but when Barnabas tried to bring John Mark back

into the team in Acts 15, Paul refused, and this resulted in a sharp disagreement between these two otherwise godly men. That was how their partnership came to an end. Yet there is evidence that Paul and John Mark were later reconciled. We read in Paul's final earthly letter: "Luke alone is with me. Get Mark and bring him with you, for he is very useful to me for ministry" (2 Tim. 4:11). What do we learn from this? It is the fact that God does not use perfect men and women to carry on his work. Sometimes we may work better when we are apart for a season. We must pray for reconciliation so that we unite our efforts to extend the work of the kingdom.

Another disappointment in Paul's ministry does not seem to have a good ending. It was the departure of Demas. Paul simply wrote to Timothy: "Do your best to come to me soon. For Demas, in love with this present world, has deserted me and gone to Thessalonica" (2 Tim. 4:9–10). Sadly, there will be such disappointments as we seek to work together for the sake of the gospel. This will happen whether we limit our joint efforts to the sphere of the local church or undertake efforts beyond. Some coworkers will abandon us because they were never real Christians. They were not regenerate. Others will abandon us because unsanctified desires have taken hold of them even though they are genuine Christians. Sometimes such individuals leave quietly. Sometimes, they want

to bring the entire edifice down on our heads. They might bring slanderous accusations against us to hurt the work we are involved in, causing our supporters to be disaffected with us and the work we are doing. This can be very painful, and it can take years to recover from it. We must not spend our energies trying to fight such battles. That would only make things worse. We should leave the Lord to fight such battles for us and press on side by side with those "earnest in many matters" for "the glory of Christ."

Conclusion

Christian Unity Is Worth Pursuing and Celebrating

AS WE CONCLUDE our brief survey of unity among the people of God, we need to pause and realize that this is something God not only initiates but also promises to bless. Therefore, we ought to pursue it and rejoice in praise of God wherever its fruit is evident for all to see.

Unity Good and Pleasant

We find this thought in a famous psalm, one that should be the desired experience among all Christians:

> Behold, how good and pleasant it is
> when brothers dwell in unity!
> It is like the precious oil on the head,

running down on the beard,
on the beard of Aaron,
running down on the collar of his robes!
It is like the dew of Hermon,
which falls on the mountains of Zion!
For there the LORD has commanded the blessing,
life forevermore. (Ps. 133)

The psalm is rich with one metaphor after another. We read of precious oil, Aaron's beard, the dew of Hermon, and the mountains of Zion. The joyful theme of unity has caused David, the psalmist, to bring together the two theaters where God displayed his grace. He pictures God's special grace by speaking about the precious oil on the head of Aaron the priest. He also depicts God's common grace by speaking about the dew of Hermon on the mountains of Zion. David calls our attention to both theaters for the purpose of eliciting our adoring wonder. Jamieson, Fausset, and Brown comment about this psalm:

As the fragrant oil is refreshing, so this affords delight. The holy anointing oil for the high priest was olive oil mixed with four of the best spices (Ex 30:22, 25, 30). Its rich profusion typified the abundance of the Spirit's graces. As the copious

dew, such as fell on Hermon, falls in fertilizing power on the mountains of Zion, so this unity is fruitful in good works.[1]

What a rich description! Unity among God's people is worth pursuing and then celebrating and rejoicing in.

For Israel, this unity meant that the Jewish tribes should learn to coexist in genuine love and cooperation. God had made them one nation by giving them a common root in Abraham, Isaac, and Jacob. He made that bond even stronger by giving them a common faith not shared by the surrounding nations. The people of Israel had a political bond and a religious one. God wanted them to maintain that unity. Where they did, they were able to fend off their enemies and win decisive victories.

When applying Psalm 133 to the Christian church, we speak in terms of unity among members of particular churches and unity among believers and churches in the wider world. In this book we have seen how God has made us one and called us to realize, maintain, and express that unity. Where this unity has been preserved, great things have been accomplished, to the glory of God.

1 Robert Jamieson, A. R. Fausset, and David Brown, *Commentary Critical and Explanatory on the Whole Bible*, vol. 1 (1871; repr., Oak Harbor, WA: Logos, 1997), 386.

Jamieson, Fausset, and Brown are right in stating that the rich profusion of anointing oil in Psalm 133 typified the abundance of the Spirit's graces. When the Holy Spirit is grieved, he withdraws his graces, and the result is nothing but spiritual barrenness, staleness, and misery. This is what often happens when there is a sinful divisiveness. But where there is love and God-honoring unity, he breathes new life, and the result is freshness, fruitfulness, and joy.

When Psalm 133 says, "There the LORD has commanded the blessing" (v. 3), it describes God giving a plentiful supply. The psalm echoes Leviticus 25, where God promised the people of Israel that if they obeyed his law, he would give them security and bless them. The people worried about every seventh year when they were supposed to give the land rest: "What shall we eat in the seventh year, if we may not sow or gather in our crop?" (v. 20). God answered, "I will command my blessing on you in the sixth year, so that it will produce a crop sufficient for three years" (v. 21). This is the picture David borrows in Psalm 133. Where there is unity, God provides unusual fruitfulness. In this case, it is not merely farming produce; it is life forevermore. Only God can give such abundant life full of love, peace, joy, salvation, sanctification, and the spread of his true worship.

In this psalm, you cannot miss the sense of refreshment and joy, and the blessing of fruitfulness and abundance. They are captured in the anointing oil, so plentiful on Aaron that it wets not only his hair but also his beard, and even reaches the collar of his priestly robes. A lavish abundance! This is what God causes to happen when his people learn to live and work together. It is never produced by a divisive spirit. Rather, divisiveness soon produces an atmosphere of tension and misery, and leads to the absence of God-honoring fruit. The witness of history is plentiful to this effect.

Are we seeing refreshment and joy, together with fruitfulness, in the ministries of those who claim to believe and preach the gospel? If not, could it possibly be because God is holding back his blessing due to a divisive spirit that grieves his Holy Spirit?

Unity Perfected in Heaven

Ultimately, the unity of the church will be seen in God's eternal kingdom. Here, in this life, we may doubt that there is "one body and one Spirit . . . one hope . . . one Lord, one faith, one baptism, one God and Father of all, who is over all and through all and in all" (Eph. 4:4–6). In heaven, there will be no doubt. That will be because there will only be one

bride of the Lord Jesus Christ, gathered from the beginning of time to his second coming. As Curtis C. Thomas puts it:

> When the Lord appears and calls us all home, we will all be back together worshiping the Lamb of God for eternity, all together around the one throne. There may be separate bodies now, but a time will come when there is but one great body.[2]

We will be gathered "from every tribe and language and people and nation" (Rev. 5:9). It will be evident not only that God has made us into "a kingdom and priests to our God" but also that he has made us to "reign on the earth" (Rev. 5:10). All of us whose names are written in the Lamb's book of life will be one bride, dressed gloriously to meet our bridegroom at the marriage feast of the Lamb and to dwell with him forever in a new heaven and a new earth, the home of righteousness. All the tears caused by a selfish and schismatic world will be dried by his loving hand as we celebrate our unity in him because the former things will have passed away (Rev. 19:6–8; 21:1–4).

2 Curtis C. Thomas, *Practical Wisdom for Pastors: Words of Encouragement and Counsel for a Lifetime of Ministry* (Wheaton, IL: Crossway, 2001), 133.

This will be the fulfillment of the longing of the saints as they prayed on earth for a unity across the social and cultural divisions of race and tribe—and even between evangelical believers in different denominations. All doctrinal arguments will be over, because our knowledge will be perfect. The intricacies of infralapsarianism and supralapsarianism will be resolved. We will all know the true *ordo salutis* (order of salvation). Even the debate between those who baptize babies and those who do not will be settled. We will also know which eschatological view was correct, because all prophecy will be turned to sight. How, then, can doctrine divide in heaven? It cannot. The only division at that time will be between those who have trusted in Christ alone for salvation and those who have not. Therein lies true evangelical unity and division. In the new heaven and new earth, there will be only "one God and Father of all, who is over all and through all and in all." It is almost unimaginable!

Unity Celebrated Now

Let us not wait until then to experience something of this blessing. As with great musical concerts, let our hearts well up in praise as we start the rehearsals now. John Goldingay exhorts us in his comments on Psalm 133:

Christian kinfolk live in breathtaking disharmony. This devastates their witness as it removes the goodness and the loveliness from them, it removes their joy and surrenders their blessing. The psalm invites us to consider the loveliness of kinfolk living as one and to meditate on the images for this that it offers, to see if this inspires us to live as one.[3]

Look around in our churches and see how the gospel has overcome so many of our social barriers between people. See how it has even overcome national and denominational barriers and enabled us to start working together. The gospel has done this. It is our very lifeblood! Because of that, let us not abandon the gospel for the sake of some nondescript, gospel-less religious unity. At the same time, let us be encouraged by the way we already overlook many lesser doctrinal and practical differences to lock arms and strive side by side for the gospel. Let us be fascinated by how true believers across the denominational divide are pouring their resources together into great gospel and kingdom causes. Let us be riveted by the graceful maturity manifested by believers who balance grace and truth, and who can differentiate between essentials and

3 John Goldingay, *Psalms*, vol. 3, *Psalms 1–41*, Baker Commentary on the Old Testament Wisdom and Psalms (Grand Rapids, MI: Baker Academic, 2008), 569.

nonessentials for the sake of the common cause. The fruit of all this is already being borne because "there the Lord has commanded the blessing, life forevermore" (Ps. 133:3). Let us begin to celebrate this evangelical unity now!

A hymn quoted in part earlier (see p. 32), "The Church's One Foundation," encapsulates everything I have written about in this book. I invite you to meditate on its remaining stanzas and let its concluding words be your prayer:

Though with a scornful wonder,
men see her sore oppressed,
by schisms rent asunder,
by heresies distressed,
yet saints their watch are keeping,
their cry goes up, "How long?"
and soon the night of weeping
shall be the morn of song!

The church shall never perish!
Her dear Lord to defend,
to guide, sustain, and cherish,
is with her to the end;
though there be those that hate her,
and false sons in her pale,

against the foe or traitor
she ever shall prevail.

'Mid toil and tribulation,
and tumult of her war,
she waits the consummation
of peace for evermore;
till with the vision glorious
her longing eyes are blest,
and the great church victorious
shall be the church at rest.

Yet she on earth hath union
with God the Three in One,
and mystic sweet communion
with those whose rest is won.
O happy ones and holy!
Lord, give us grace that we,
like them, the meek and lowly,
on high may dwell with Thee.[4]

4 S. J. Stone, "The Church's One Foundation" (1866), https://hymnary.org/.

Acknowledgments

IN MY WORK AS A PASTOR, I find that I am ever indebted to several individuals to get a writing project done. It is only right that I thank them for their help.

A group of pastors and pastoral interns went through each chapter with me, giving me valuable insight by way of feedback. Alex Mutale, Chipita Sibale, Collins Sakalunda, Curtis Chirwa, Emmanuel Chileshe, Erick Akah, Joseph Chisola, Kennedy Kawambale, Michael Mwanza, Mike Musafiri, Million Kambuli, Mwindula Mbewe, Obby Lubumbe, Oswald Sichula, Esaya Nkhata, Sebio Yawila, and Zinga Banda, thank you for sparing so much of your time to help me with this project. Your input was invaluable.

Then, behind the scenes, are my office assistant, Irene Maboshe, and my ministry assistant, Francis Kaunda. You take care of so many details in my life and ministry that it would

fill a page to recount them. Your care, however, frees me up to handle other challenges, such as the writing of this book. I am grateful for the diligence with which you do your work.

I am also grateful to the elders at Kabwata Baptist Church, Lusaka, Zambia, who have recognized the need for me to write books for the wider church and have given me the time to do so. This often means that you carry a greater load of eldership work to free me to do the work of an author. I truly appreciate this.

Finally, I want to thank my wife, Felistas. You are the "helper suitable" for me par excellence! Without your help and sacrifice in more ways than I can count, this project would not have been done. I owe you more than words can tell.

General Index

Scripture Index

Union

We fuel reformation in churches and lives.

Union Publishing invests in the next generation of leaders with theology that gives them a taste for a deeper knowledge of God. From books to our free online content, we are committed to producing excellent resources that will refresh, transform, and grow believers and their churches.

We want people everywhere to know, love, and enjoy God, glorifying him in everything they do. For this reason, we've collected hundreds of free articles, podcasts, book chapters, and video content for our free online collection. We also produce a fresh stream of written, audio, and video resources to help you to be more fully alive in the truth, goodness, and beauty of Jesus.

If you are hungry for reformational resources that will help you delight in God and grow in Christ, we'd love for you to visit us at unionpublishing.org.

unionpublishing.org

The Growing Gospel Integrity Series

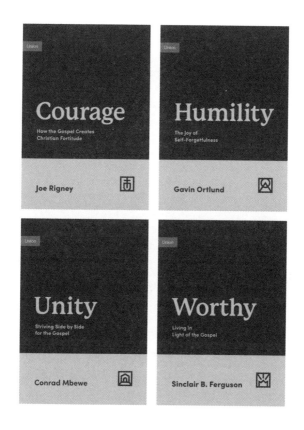

For more information, visit **crossway.org**.